WORDS FROM A FASHION ICON

MARILYN
MONROE

For Kerrie
and the wonderful words
of wisdom that she has
always given me.

WORDS FROM A FASHION ICON

MARILYN MONROE

Megan Hess

Hardie Grant

BOOKS

Contents

INTRODUCTION	7
On style	21
On stardom	41
On life	61
On creativity	81
On determination	101
On relationships	121
THANK YOU	141
ABOUT THE AUTHOR	142

Introduction

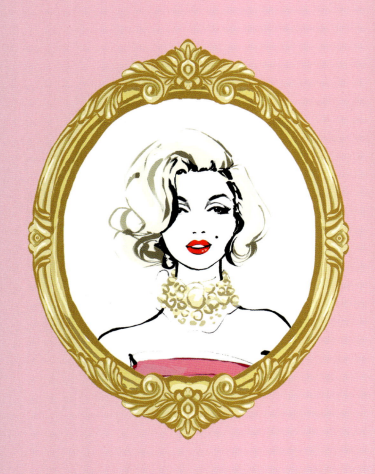

I have always been moved by the story of Marilyn Monroe.

Her life was shadowed by sadness but, even so, she was luminously beautiful on film, clever and determined to succeed, and brilliant as both a musician and a comedian. She was at the centre of several milestone style moments that made an indelible mark in the fashion world.

Marilyn Monroe or, as her mother named her, Norma Jeane Mortenson, was born in Los Angeles in 1926. She rose to stardom after a difficult childhood, during which she shuffled between foster homes and an orphanage. Her mother suffered from mental illness and little Norma Jean experienced great neglect. As a small girl, she would go alone to the movies and watch the big silver screen – it was one of the few things that she enjoyed at that age. When Marilyn was 16, she married a 21-year-old sailor, James Dougherty, to escape being returned to state care.

When James went to sea as a merchant marine during the Second World War (1939–1945), Norma found employment at a weapons factory, where she worked extremely hard. Here, she was photographed in a series of publicity images of women supporting the war effort. The photographer told her she could be a model and she realised that it paid better than factory work. She also saw modelling as a route to working in movies, which was something she had always dreamed of. In 1946, Norma Jean was signed by a modelling agency; she divorced James that same year and started focusing on her new career.

Norma Jean soon took on the stage name of Marilyn Monroe, and rose like a comet through Hollywood, first as a model, then as a blonde starlet, and finally as a queen of the screen and of style. Several of her looks have become iconic in history. There is possibly not a more famous, more imitated dress than the white halter-neck dress she wore while standing over the cooling breeze of a subway grate in the movie *The Seven Year Itch* (1955). The shocking pink satin gown that moved with her body as she danced to 'Diamonds are a girl's best friend' has influenced designers ever since. The glittering, skin-tight dress Marilyn wore in 1962 to sing 'Happy birthday, Mr President' to John F. Kennedy is almost as famous as the sound of her distinctive, sultry singing voice.

For nine months in 1954 to 1955, Marilyn was married to professional baseball player Joe DiMaggio, who is said to have wanted her to stop acting. But acting was what Marilyn Monroe wanted more than anything. Even at the peak of her stardom, Marilyn continued to work on her craft as a performer: she attended regular classes, employed an acting coach and always sought to improve her skills. She was a perfectionist who would re-take shots and re-record singing tracks over and over again, wanting to get them just right.

Marilyn sought to be taken seriously at a time when the intelligence of a woman with her overt sexuality was dismissed. Marilyn's performances were known for their seductiveness and her characteristic hip-swaying walk became synonymous with Hollywood glamour. She was often cast as the 'blonde bombshell' in roles not notable for the character's intelligence, but people who knew her well said that Marilyn was a very serious person. She was a businesswoman who battled with the movie studios, seeking better conditions; at one point, she set up her own production house. Marilyn was a book-lover who read Rilke's *Letters to a Young Poet*, and kept writers like Emily Dickinson, James Joyce and Gustave Flaubert on her shelf. She wrote poems, which were published after she died in *Fragments*. Marilyn often chose to be photographed reading.

Marilyn married the playwright Arthur Miller in 1956, and stood by him during the McCarthy era, when he was called to appear before the House Un-American Activities Committee. She was friends with the novelist Truman Capote, and impressed the British poet Edith Sitwell. She worked alongside Hollywood greats, including Clark Gable, Laurence Olivier, Betty Grable and Lauren Bacall.

Marilyn was beloved by the people and was often mobbed by crowds, even when she sought peace. She had an air of fragile vulnerability that sparked a protective instinct in some who knew her. As a symbolic public figure, Marilyn was part of a society-wide conversation about feminine weakness and feminine power.

In Gentlemen Prefer Blondes (1953) – a musical romp about a pair of showgirls looking for love (and diamonds) – Marilyn acted alongside Jane Russell. Ostensibly the story of a young woman looking to marry a millionaire, the movie focuses on the joyful friendship of two women, who support each other loyally through hilarious misadventure, while wearing stunning outfits. In the final double wedding scene, Jane and Marilyn's characters stand together, with their hard-won grooms either side. The camera zooms closer and closer until the men are out of the frame. The movie closes as the two brides look at each other and smile in a moment of shared triumph and an affirmation of their friendship.

Unfortunately, despite moments of joy, Marilyn Monroe's life had some bitter hardships. After miscarrying twice and divorcing Arthur Miller, she was too unwell to finish her final movie, *Something's Got to Give* (1962). Marilyn, struggling with her mental health, died from an overdose of sleeping pills in 1962. Her sudden death shocked the world and inspired Elton John's heartbreaking lament 'Candle in the wind'.

Marilyn Monroe inspired artists from Andy Warhol to Madonna. All kinds of people have had a lot to say about her; however, her own words have much to tell us. Marilyn saw and learnt a lot in her brief 36 years and amassed wisdom about relationships, creativity, stardom and, of course, style. A true icon of glamour, whose style has never been matched. I hope you'll find these quotes as inspiring as I do.

Megan Hess

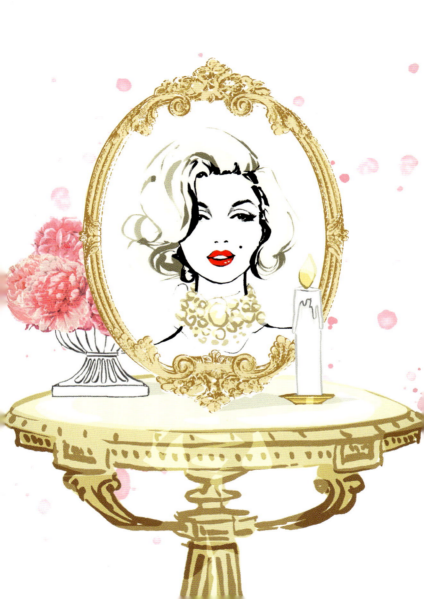

On style

Marilyn Monroe was known for her signature style, with her hair in soft platinum blonde waves, bright red lipstick, her characteristic beauty spot, and clothes that accentuated her curves. She also had an incognito look for when she was trying to dodge the spotlight, which itself had movie star glamour: big dark glasses covering half her face and a scarf over her hair.

Diamonds are a girl's best friend.

The dress was *cool and clean* in a dirty, dirty city.

**WILLIAM TRAVILLA,
COSTUME DESIGNER**

I like to be
really dressed up,
or really undressed.
I don't bother
with anything
in between.

I like bare-looking *shoes* for both formal and informal *occasions.* I believe, like the *classic Greeks,* that a woman's feet are an important part of *her beauty.*

I have always felt *comfortable* in blue jeans. They're my *favourite* informal attire.

Monroe was *heavenly to dress.* She looked even *more gorgeous* without any make-up on, sitting around in this beat-up *terry cloth bathrobe.* I used to make her *pancakes with caviar* and sour cream.

**GEORGE NARDIELLO,
DESIGNER**

Once this fellow says, 'Marilyn, what do you wear to bed?' So I said, 'I only wear *Chanel No. 5.*'

Beauty and femininity *are ageless* and can't be contrived, and *glamour*, although the manufacturers won't like this, *cannot* be manufactured.

On stardom

Marilyn Monroe's relationship with stardom was fraught. When she was younger, she had longed to be a movie star and found it incredible to see her name in lights. However, fame resulted in some members of the public being disrespectful and, at times, Marilyn longed for privacy. Nonetheless, she was deeply grateful to the fans who loved her and who she believed made her a star.

I used to think
as I looked out on the
Hollywood night,
'There must be thousands
of girls sitting alone
like me dreaming of
being a *movie star.*
But I'm not going
to worry about them.
I'm *dreaming* the hardest.'

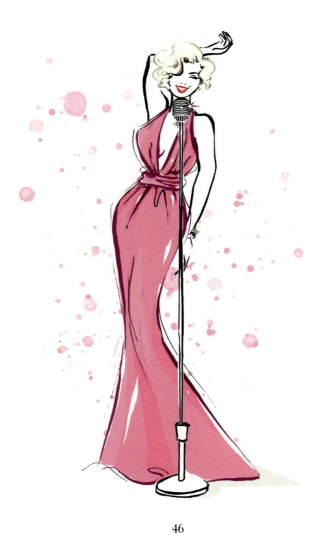

There was like
a hush over the place
when I came on to sing
Happy Birthday.
Then, you think, by God,
I'll *sing* this song
if it's the *last thing*
I ever do.

The minute *that camera* turned on her, she became this *incredible* creature ... She was just herself, and she was absolutely *dazzling* as herself.

**LAUREN BACALL,
ACTRESS**

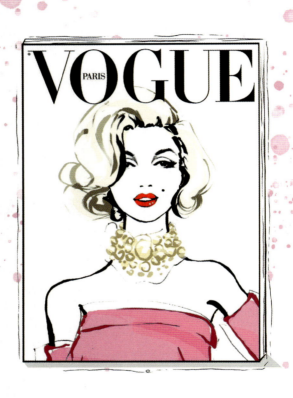

When you're famous you run into human nature in a raw kind of way. It stirs up envy, fame does.

Sometimes it would be a big *relief* to be no longer *famous.*

There was *my name* up in *lights*. I said, 'God, somebody's made a *mistake*.' But there it was, *in lights*.

Fame is like caviar, you know – it's good to have caviar but not when you have it at every meal.

Marilyn Monroe was a *legend*... For the entire *world* she became a *symbol* of the eternal *feminine*.

**LEE STRASBURG,
ACTING COACH**

On life

Marilyn Monroe's experiences can teach us about life. She had her share of suffering and joy. She saw a therapist to gain a deeper understanding of the human psyche, believing this would make her a better actor. She gathered wisdom from the world around her and was a serious reader, moving among brilliant thinkers.

We should all start to *live* before we get too old. *Fear* is stupid. So are *regrets*.

Keep smiling, because life is a beautiful thing and there's so much to smile about.

We are all of us *stars,* and we deserve to *twinkle.*

I like to *have time*
for the things I do.
I think that we're rushing
too much nowadays.
How can you do
anything *perfect* under
such conditions?
Perfection takes time.

Respect is one of life's greatest treasures.

What the world *really* *needs* is a real feeling of *kinship.*

On *Sunday,* which is my one day of total *leisure,* I sometimes take two hours to *wake up,* *luxuriating* in every last moment of *drowsiness.*

Love and work
are the only things
that *really*
happen to us.
Everything else
doesn't really
matter.

On creativity

Marilyn Monroe was fascinated by creativity. She took acting classes throughout her career and collaborated closely with several coaches. She worked hard to perfect her timing and delivery skills, and developed the way she interacted with the camera. She was also a singer and a poet and, of course, her creative flair took visible form in her iconic style choices.

Creativity has got to start with humanity.

I know of few *actresses* who have this *incredible talent* for communicating with a *camera lens*. She would try and *seduce* the camera as if it were a *human being.*

**PHILIPPE HALSMAN,
PHOTOGRAPHER**

I don't want to *make money,* I just want to *be wonderful.*

I'm ready.
I want to work.
Acting is
my life.

The *sensitivity* that helps me to act, you see, also makes me react. *An actor* is supposed to be a *sensitive* instrument.

I didn't want *anything* else. Not men, not love, not money, but the ability *to act.*

I *restore* myself when I'm alone. A *career* is born in public – *talent* in privacy.

She is a *master* of delivery. She can read *comedy* better than anyone else in the *world.*

**BILLY WILDER,
FILMMAKER**

On determination

A rags-to-riches story often has elements of luck, and Marilyn Monroe certainly had her lucky moments. However, Marilyn's story is also one of determination and persistence. She used her intelligence and business acumen to advance her career and get herself exactly where she wanted to be: a star on the silver screen.

A *wise* girl knows her limits,
a *smart* girl knows that she *has none.*

I *don't* stop when I'm *tired.*
I only stop when I'm *done.*

I live to *succeed,* not to *please* you or *anyone* else.

If I'd observed
all the *rules,*
I'd never have got
anywhere.

Always, always, always believe in yourself. Because if you don't then who will, sweetie?

Someone said to me, 'If 50 per cent of *experts* in Hollywood said you had *no talent* and should give up, what would you do?' *My answer* was then and still is, 'If 100 per cent told me that, all 100 per cent would be *wrong*.'

I was *born under* the *same sign* as Ralph Waldo Emerson, Queen Victoria and *and* Walt Whitman.

You don't
have to know
anything
To dream hard.

On
relationships

After a series of complex relationships, including three very different marriages, Marilyn Monroe had a lot to say about love, and not just the romantic kind. She had friends and colleagues who adored her and a few special people who stood in for the family she never really had.

A girl doesn't need anyone who doesn't need her.

I seldom write letters but I *love* calling friends, *especially* late at night when I can't sleep.

I don't *forgive* people because I'm weak, I *forgive* them because I am *strong enough* to know people *make mistakes.*

Forgive me for being sentimental. I'm *so glad* you were born and that I'm *living* at the same time *as you.*

I've *never* dropped
dropped
anyone
I believed in.

She understood me somehow. She knew what it was like to be young. And I loved her dearly.

**MARILYN MONROE,
SPEAKING OF HER CARER ANA LOWER**

People are *funny*.
They ask you a
question and when
you're *honest,*
they're shocked.

Thank you

To Jasmin Chua for jumping onto a moving train and creating our first book series together! The first of many more wonderful books to come.

An enormous thank you to Staci Barr, who has meticulously worked on every single page of this book to help bring it to life.

To Martina Granolic for your never-ending enthusiasm.

To Ailsa Wild for researching every single quote and interesting fact about our icons – you could also work for the FBI!

To Murray Batten for bringing everything together and creating such a joyful and elegant design for this series.

To Todd Rechner for your incredible care and perfection in seeing all my books to their finished form.

To my husband Craig and my children Gwyn and Will for being my biggest inspiration.

About the author

Megan Hess was destined to draw.

After working in graphic design and art direction, Megan illustrated Candace Bushnell's bestselling book *Sex and the City* in 2008. Her career in fashion illustration has since seen her creating for renowned clients all over the world, including portraits for *Vanity Fair*, animations for Prada in Milan, the windows of Bergdorf Goodman in New York, and live illustrating for fashion shows such as Christian Dior Couture. Megan is the author of many bestselling fashion books and two sensational series for children: *Claris: The Chicest Mouse in Paris* and *Young Queens Collection*.

Visit Megan at meganhess.com

Published in 2025 by Hardie Grant Books,
an imprint of Hardie Grant Publishing
Hardie Grant Books (Melbourne)

Wurundjeri Country
Building 1, 658 Church Street
Richmond, Victoria 3121

Hardie Grant North America
2912 Telegraph Ave
Berkeley, California 94705

hardiegrant.com/books

Hardie Grant acknowledges the Traditional Owners of the Country on which we work, the Wurundjeri People of the Kulin Nation and the Gadigal People of the Eora Nation, and recognises their continuing connection to the land, waters and culture. We pay our respects to their Elders past and present.

All rights reserved. No part of this publication may be reproduced, stored in a retrieval system or transmitted in any form by any means, electronic, mechanical, photocopying, recording or otherwise, without the prior written permission of the publishers and copyright holders.

The moral rights of the author have been asserted.

Copyright text and illustrations
© Megan Hess 2025

Copyright design
© Hardie Grant Publishing 2025

A catalogue record for this book is available from the National Library of Australia

Words from a Fashion Icon: Marilyn Monroe
ISBN 978 1 76145 135 5
ISBN 978 1 76144 250 6 (ebook)

10 9 8 7 6 5 4 3 2 1

Publisher: Jasmin Chua
Project Editor: Antonietta Anello
Researcher: Ailsa Wild
Creative Director: Kristin Thomas
Designer: Murray Batten
Head of Production: Todd Rechner
Production Controller: Jessica Harvie

Colour reproduction by
Splitting Image Colour Studio

Printed in China by Leo Paper Products LTD.

The paper this book is printed on is from FSC®-certified forests and other sources. FSC® promotes environmentally responsible, socially beneficial and economically viable management of the world's forests.

Every effort has been made to ensure that the information in this book is accurate at the time of going to press. The publisher welcomes information and suggestions for correction and improvement. All trademarks, copyright, quotations, company names, registered names and products used or cited in this book are the property of their respective owners. This title is not affiliated with or endorsed by any person or entity. In the research for this book, quotes have been stated in various sources:

Magazines and newspapers: *Daily News, Elle, Good Housekeeping, Harpers Bazaar, The Guardian, Literary Hub, Los Angeles Times, The Paris Review, Time, Vanity Fair, Vogue*; **Books:** *Portraits and Observations*, by Truman Capote, 2008; *Marilyn Monroe: The Last Interview*, by Sady Doyle, 2020; *Four Faces of Femininity: Heroic Women Throughout History*, by Barbara McNally, 2020; *Dressing Marilyn*, by Andrew Hansford, 2012; *My Story*, by Marilyn Monroe with Ben Hech, 2007; *Marilyn, Her Life in Her Own Words*, by Marilyn Monroe, 2003; *Marilyn on Marilyn*, by Marilyn Monroe, 1983; *Fragments, by Marilyn Monroe*, 2010; *Marilyn in Fashion*, by Christopher Nickens, 2012; *Marilyn Monroe and the Camera*, by Georges Belmont and Jane Russel, 1989; *Marilyn: Norma Jean*, by Gloria Steinem,1986; *Conversations with Marilyn*, by William J. Weatherby, 1976;
Websites: OpenCulture.com, Criterion.com